THE pip EXPANDED GUIDE TO THE
NIKON F80 / N80

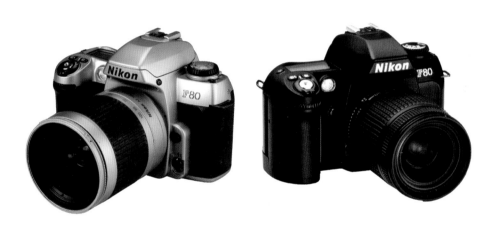

Matthew Dennis

photographers'
pip
institute press

THE pip EXPANDED GUIDE TO THE
NIKON F80 / N80

Matthew Dennis

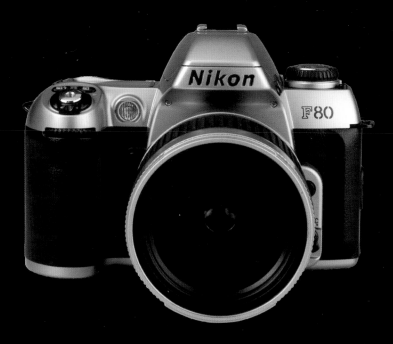

photographers'
pip
institute press

First published 2004 by
Photographers' Institute Press / PIP
166 High Street, Lewes
East Sussex BN7 1XU

Text © Matthew Dennis 2004
© in the work Photographers' Institute Press / PIP

ISBN 1 86108 348 3

British Cataloguing in Publication Data
A catalogue record of this book is available from the British Library.

Typefaces: Frutiger and Sabon
Colour origination by Icon Reproduction
Printed in Hong Kong by H & Y Printing Ltd

THE NIKON F80 / N80

If you are reading this, it is probably for one of two reasons: you are either considering buying a Nikon F80 / N80, or have bought one and wish to be able to stretch the camera to the limits.

Before we head into the main body of the book, it is worth pausing a moment to look at the camera and its place in history. The Nikon F80 / N80 like many cameras of its generation is a hybrid of production technology and the standardization of components. What this means is that the camera incorporates many facets of technology from high-end cameras, yet is produced at a very reasonable price.

The sophistication of the camera is such that it has been used as a basis for a number of digital SLRs costing four and five times as much as it does. As a measure of the quality of the camera, this fact alone is a telling one. No manufacturer in their right mind would produce a four-figure camera unless the technology at the heart of it was a proven winner... and on many levels the F80 / N80 is most definitely that.

Its focusing system is quick and sure, its exposure system was, at its launch, the most sophisticated ever seen on a camera of its price, and the handling characteristics are of a level of simplicity on a par with cameras bearing nowhere near as many features.

It is a camera of many parts, a model whose lineage can be traced back through professional models launched only a few years previously, and whose specification is wide and varied. It is a big camera in a small body whose vast specification, when used appropriately, can be applied to pretty much all shooting situations. Welcome to the Nikon F80 / N80.

Contents

How the **F80 / N80 evolved**

The basic principles of how a camera operates have remained unchanged since the camera's invention.

In the 11th century the camera obscura (literally meaning 'dark chamber'), consisting of a room with a small hole in an outside wall, was used to observe solar eclipses. Rays of light passing through the hole would produce an image of the outside on a screen within the room.

Permanent Image
In 1824 a French lithographer, Nicéphore Niépce, discovered that by coating a pewter plate with asphaltum a permanent image could be recorded. In 1841, in

1959
Although Nikon wasn't the first Japanese manufacturer to launch an SLR, the F was nonetheless a sensation. The use of interchangeable viewfinders, 100% image viewing and an automatic instant return mirror made the F a compelling camera.

1971
Launched on 21 September 1971 the Nikon F2 followed the design philosophy of being 'quicker and stronger' than the Nikon F. While it seemed a small step in terms of design, it had significantly enhanced user-control and an improved motor drive system.

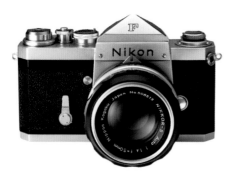

England, William Henry Fox Talbot patented the Calotype – a negative-positive process using paper treated with nitrate of silver – six years after producing the first negative in 1835.

The Perfect Camera
The basic criteria for the production of photographs have changed little since then, but the design of the principle apparatus used in photography, the camera, is on-going, reminiscent of the search for the Holy Grail. Of course, there is no such thing as the 'perfect camera'. Everything in photography is subject to compromise – what is good in one respect can lead to deficiencies in another. More often than not, camera design is a question of quality versus practicality... and of course cost. The enduring question of choice has therefore had a lasting influence on the way cameras have been designed over the decades.

Large-format field cameras, using sheet film, bellows and viewing screens, as well as the obligatory tripod, are cumbersome and slow to operate, requiring painstaking adjustments. Yet, when used properly, they offer total

1980
The Nikon F3 incorporated the then cutting-edge technology of an electronically controlled shutter. This allowed the inclusion of an Automatic Exposure (AE) function and added fine control to long-time exposures. The F3 also had a viewfinder LCD – a first.

1988
The Nikon F4 launched in September 1988 and was the first professional camera from Nikon to incorporate autofocus. It also featured weather protection and shutter balancing as well as a huge host of other functions.

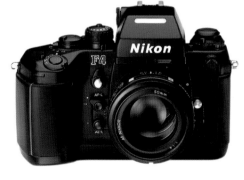

control over the picture-making process and deliver images of unparalleled quality that are still in demand in many commercial fields. The pursuit of designing a camera that combined acceptable image quality with expediency led to the development and refinement of the small-format camera.

Photography for the People

With the aim that, once freed from the constraints of the tripod, the studio and the chemist's bench, the camera would open up new photographic frontiers, George Eastman developed the Kodak 'Box Brownie'. For the first time in photographic history knowledge of optics and chemistry was no longer an essential requirement for photographers.

Further developments in the early 20th century, such as the first Leica – which combined the advantages of a small portable camera with the potential for using readily available cinematographic 35mm film – blazed the trail for the cameras we know today. Subsequent development of innovative and high-quality optics, together with improvements in film – and latterly, digital – technology, allowed small-format cameras, practical in their portability and flexibility, to produce ever-improving image quality, which can be indistinguishable from that of its larger cousins.

Camera designers have progressively continued the process of taking the onus of knowledge from the user, and automating the

1994

The Nikon F50 was an inexpensive yet highly sophisticated autofocus SLR designed for the mass-market. In many ways it was the direct ancestor of the Nikon F80 / N80.

1996

The Nikon F5 model brought new autofocus and especially exposure metering sophistication to the autofocus SLR market. Where it led the F80 / N80 now follows.

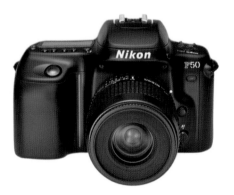

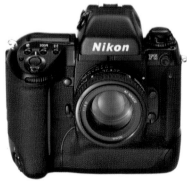

camera more and more. Whereas early 35mm cameras required an understanding of the relationship between shutter speed and aperture in controlling exposure, for example, modern electronic cameras with their multiple program settings allow users to create perfectly acceptable images without knowing even the basic fundamentals of photography.

Taking Control

In order to achieve individualism in photography it is necessary for the photographer to wrest back control of the decision-making process from the camera. The ability to make the camera perform to our own wishes, to use the available technology to its limitations – and sometimes beyond – are what sets

the photographer apart from the 'snapper'. The purpose of this book is to provide you, the user or potential user of the Nikon F80 / N80, with the necessary knowledge to operate the camera to its and your own full potential.

Develop Your Own Style

More than simply a manual, this book shares my knowledge of the camera, its back-up system and its handling in everyday situations, to give you the know-how to develop your own photographic style. *The PIP Expanded Guide to the Nikon F80 / N80* will take you on a step-by-step tour of this remarkable modern camera and let you maximize your picture-taking opportunities and get the most out of your camera and photography.

1998

More than just a fixed pentaprism model of the F5, the F100 started the downward sizing of high technology that would ultimately lead to the Nikon F80 / N80.

2000

The Nikon F80 / N80 combines aspects of the F50, F100 and F5 with some brand new features of its own, in an inexpensive yet highly sophisticated form.

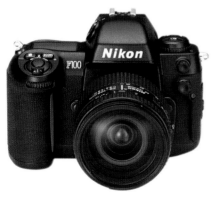

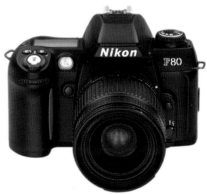

Chapter **1**

Introduction to the **F80 / N80**

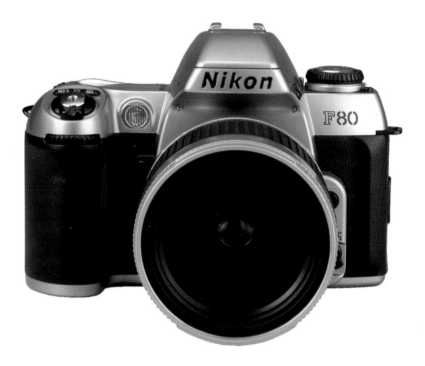

The Nikon F80 / N80 was Nikon's first SLR of the new millennium, announced in January 2000. It is a mid-range camera that, when it was launched, bridged the gap between the entry level F70 and the professional F100 and F5 models. As such, it incorporates many of the technological advances found on the F100 and F5, bringing some exciting high-end functions to a wider audience. The Nikon F80 / N80 is not just a stripped-down version of 'better' cameras, it heralded some new features of its own.

When launched, there was no other high specification camera at such a low price. It comes in several incarnations, the basic F80 / N80, and the F80D / N80D, which includes a data back. Both models are available in two finishes: black only, and black and silver. There is also the F80S / N80S, this has a data back that prints exposure information between film frames. This is only available in black.

The F80 / N80 has also proved to be a perfect base for digital cameras and has been adopted by

Nikon for its D100, as well as being used as the basis for the Fujifilm S2 Pro and Kodak DCS Pro 14N.

Lenses use Nikon's F-system bayonet lens mount, a design that has existed since 1959. This means that the F80 can be used with practically any Nikon lens made since then, although the available functions may vary.

Modern Nikkor lenses take advantage of the Nikon F80 / N80's cross-ranged five-area AF sensors, and the multi-CAM900 AF module specially designed for the camera. Similarly, the camera's viewfinder is the first to feature Nikon's Vari-Brite Focus Area display, making the F80 / N80 the first SLR to feature a Polymer Network LCD. This highlights selected focus areas in black, or in red in low light. The F80 / N80 has inherited the advanced exposure system from the F100. This incorporates 3D matrix metering which only works with AF-D and later Nikkor lens series.

The camera is comfortable to use. It feels light, yet is still reassuringly robust. The controls are well placed and accessible, while all the shooting data you need to know while shooting is visible within the viewfinder and on the top LCD panel. This ensures that the camera is quick and easy to use, allowing you to concentrate on your subject.

Main features

Focus Cross-ranged, five-area multi-CAM900 AF sensor with wide horizontal and vertical coverage. Three autofocus area modes: dynamic (shifts from one sensor to another when tracking moving subjects), closest subject priority and single area. There is an AF assist illuminator for autofocus operation in subdued light.

Exposure 3D matrix metering using a database of over 30,000 scenes of shooting information for exposure evaluation with the ten-segment matrix sensor. There is also centre-weighted and spot metering, which takes readings based on the selected AF sensor and four exposure modes: programmed-auto (with Flexible Program); shutter-priority-auto; aperture-priority-auto and manual. The F80 / N80 also offers auto-bracketing and exposure compensation.

Built-in Speedlight Balanced fill-in-flash metering is available with the built-in Speedlight and compatible external units. Higher than usual position allows better subject coverage with larger diameter lenses. It has a guide number of 12m at ISO 100.

Custom settings The F80 / N80 allows the custom setting of 18 sets of options to make the camera handle as you wish.

System back-up There's an external battery pack, cable release plus all of Nikon's F-mount lenses.

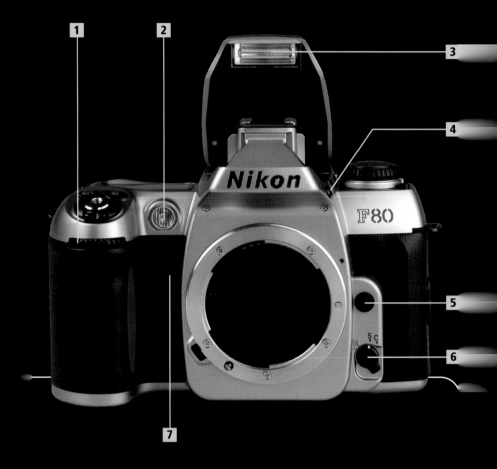

FRONT OF CAMERA

1 Sub-command dial

2 AF Assist illuminator / Red eye
reduction lamp / Self-timer
indicator

3 Built-in Speedlight flash unit

4 Flash lock-release button

5 Lens release button

6 Focus mode selector

7 Depth of field preview button

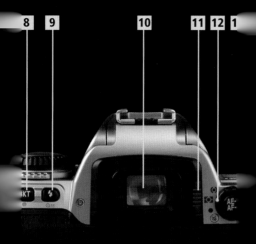

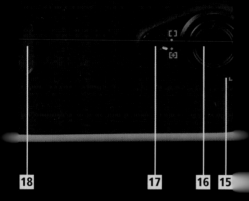

OF CAMERA

to exposure bracketing button **14** Ma

sh sync / Rewind button **15** Foc

wfinder eyepiece **16** Foc

ptre adjustment slider **17** AF

tering system selector **18** Film

Lock / AE-Lock

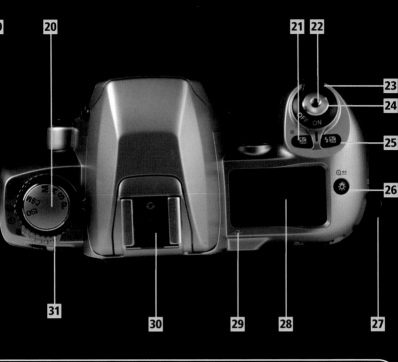

TOP OF CAMERA

19 Camera strap eyelet

20 Exposure mode / Custom setting / ISO film speed select dial

21 Exposure compensation button

22 Cable release terminal

23 Power switch

24 Shutter release button

25 Flash exposure compensation button

26 LCD illuminator / Rewind button

27 Camera strap eyelet

28 LCD panel

29 Film plane indicator

30 Accessory shoe

31 Film advance mode selector

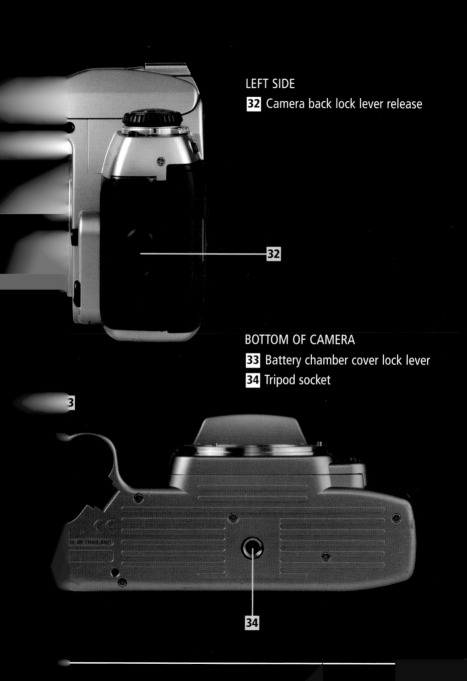

LEFT SIDE

32 Camera back lock lever release

BOTTOM OF CAMERA

33 Battery chamber cover lock lever

34 Tripod socket

Frequently used features

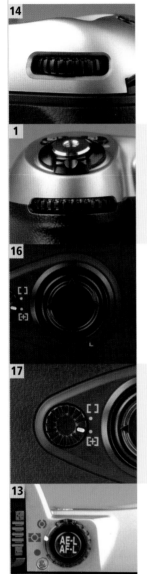

Main-command dial 14
Used to select the shutter speed when operating the camera in shutter-priority-auto exposure mode or manual exposure mode. Also used to select the exposure compensation, as well as setting custom functions.

Sub-command dial 1
Used to select the aperture of the lens when operating the camera in aperture-priority-auto exposure mode or manual exposure mode.

Focus area selector 16
Used to select the area of focus when operating the camera in single area AF mode. Pressing the focus area selector will shift the selected focus area in the corresponding direction of the arrow pressed.

AF area mode selector 17
Allows you to select between single area AF, that uses one selected focus area, or dynamic AF, that utilizes the other four focus areas.

AE-L/AF-L button 13
Automatically locks both exposure and focus. Can be set to lock either exposure only or focus only via the custom function setting.

Dioptre adjustment slider **11**

Allows near- or far-sighted photographers to adjust the eyepiece dioptre within a range of −1.8 to +0.8 dioptres to aid manual focusing.

Depth of field preview button **7**

Pressing the depth of field preview button will temporarily stop the lens down to the set aperture enabling examination of the available depth of field before firing the shutter.

LCD illuminator button / Rewind button **26**

Pressing the LCD illuminator button will activate a green light in the LCD panel, enhancing visibility of the data displayed in the window in low light situations. This button also doubles as one of the two rewind buttons.

Exposure mode dial **20**

Allows the user to select programmed-auto, shutter-priority-auto, aperture-priority-auto or manual exposure mode. Also accesses the range of custom settings on the F80 / N80. Turning the dial to the ISO speed setting allows the user to change the film speed from the default DX setting.

Film advance mode selector **31**

Allows you to choose from single frame advance, continuous film advance and multiple exposure. There is also a setting for the self-timer.

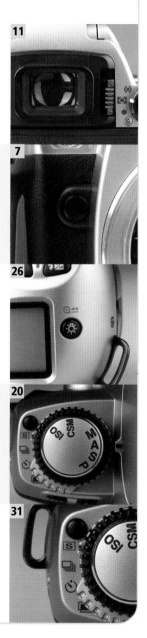

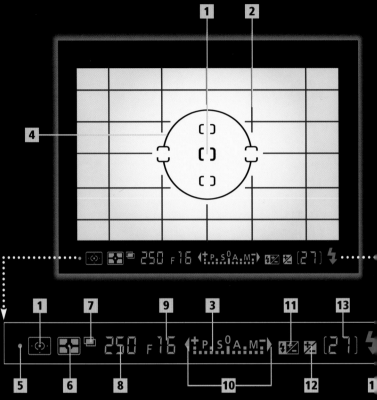

1 Focus area indicators / Spot metering area (4mm diameter)
2 On-demand grid lines
3 Exposure level
4 12mm diameter reference circle (for centre-weighted metering)
5 Focus Indicator
6 Metering system
7 Multiple exposure / AE-L indicator
8 Shutter speed
9 Aperture
10 Exposure mode / Electronic analogue exposure display Exposure compensation val display
11 Flash exposure compensati
12 Exposure compensation
13 Frame counter / Exposure compensation value / Flash exposure compensation val
14 Flash ready light

Top LCD panel indications

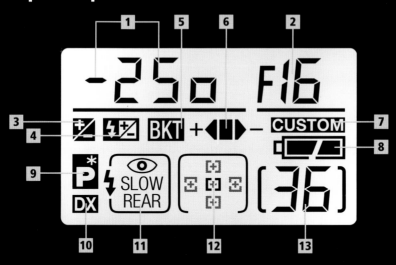

1 Shutter speed / Exposure compensation value

2 Aperture

3 Exposure compensation

4 Flash exposure compensation

5 Auto exposure bracketing

6 Bracketing bar graphs

7 Custom setting

8 Battery power

9 Flexible Program

10 DX indication

11 Flash sync mode

12 Focus area

13 Frame counter

Operating the F80 / N80 command dials

The F80 / N80 uses main- and sub-command dials, in isolation or in conjunction with other buttons to select and set various modes and functions. The following table illustrates each available operation.

Main-command dial – by itself

1) Rotating when in shutter-priority-auto or manual exposure mode will select the shutter speed.

2) Rotating when in programmed-auto exposure mode will perform Flexible Program.

Main-command dial – in operation with other buttons

Selecting exposure compensation.

Selecting DX-coded film speed or manually setting film speed.

Setting/cancelling auto exposure or flash exposure bracketing.

Selecting flash sync mode.

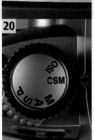

Selecting the custom function menu.

Sub-command dial – by itself

Rotating when in aperture-priority-auto or manual exposure modes will select the lens aperture.

Sub-command dial – in operation with other buttons

Setting additional exposures and compensation value in the auto exposure and flash exposure bracketing mode.

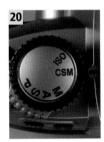

Selecting and making a custom function option.

Focus area selector

Pressing one of the focus area selector arrows changes the focus area in the corresponding direction.

Chapter **2**

Operational guide

Getting started

Compared to many older cameras or for a newcomer to photography, the array of buttons and dials on this camera may initially seem quite daunting. It may be tempting to set the camera to programmed-auto and thus to neglect the rest of the controls. That would be a mistake because the variety of control on the F80 / N80 should greatly enhance your enjoyment of it, and consequently of your photography. In this section we're going to focus on expanding your familiarity with the camera and setting it up to suit your own style and needs. It is quite a simple camera to operate but to make the most of the camera you need be able to control it in such a way that it adds to your creative vision and your ability to take the pictures you want.

Reference point

The aim of this chapter is to act as your personal reference guide, to be revisited as the demands you make on your camera increase, and to complement your photographic development in a similar way to your F80 / N80.

Because the F80 / N80 is a mid-range camera, I am assuming some photographic knowledge. But it may be your first introduction to Nikon, by way of another system, or you may be a newcomer to modern cameras, having previously used manual cameras.

The purpose of this chapter is to cover not just how the camera works, but also how to adapt it to your own requirements and goals. At first you may find yourself concentrating on some of the more practical, everyday operations of the camera. As your skills and your vision develop, you will want to gain a greater understanding of some of the custom features the camera offers. Presumably you have chosen the camera because it offers a way to advance your skills, or to perform tasks that lesser cameras can't cope with. Either way there is a learning process involved in order to achieve your aims.

To aid this process this chapter starts with some of the more basic functions before moving on to more advanced operations, such as custom functions.